Larry Kagan
LYING SHADOWS

THE HYDE COLLECTION

CONTENTS

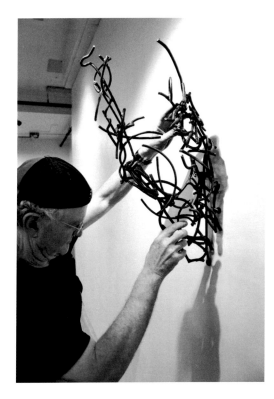

FOREWORD

Whenever one examines a two-dimensional work of art that portrays a realistic rendition of the subject, as we see in Larry Kagan's shadows, two considerations usually come into play. The first is how the illusion was achieved, and the second is how successful and engaging the method was in creating the illusion.

To clarify by example, a painting of a building uses paint on canvas as its medium. Both the style by which the paint is applied, and the artist's use of perspective—the method—create the effect of a three-dimensional object in a two-dimensional space. The viewer usually starts by seeing the painted image from afar as a highly realistic rendition in three dimensions, but as he or she approaches the painting, the source of the illusion becomes apparent: strategically placed, abstract dabs of paint form the illusion of reality.

In Larry Kagan's work, abstract sculptural elements are formed from welded quarter-inch sections of bent steel wire. To follow the painting analogy further, these abstract, three-dimensional sculptural forms are the medium. By themselves, or through indiscriminate lighting, they exist simply as engaging abstract sculptures that cast abstract shadows. However, through the method of deliberately lighting the works from a specific point in space, the sculptures reveal careful internal structures that cast highly realistic shadows: an image of a chair, or a shoe, or some other object or person. As in the painting example, the illusion of reality is complete, and the effect is captivating.

What makes Kagan's work so intriguing is his approach: we viewers become intimately involved within the abstract complexity of both the medium and the method as we marvel at the resulting content.

The Hyde Collection is pleased to have the opportunity to exhibit the latest work by Larry Kagan.

Charles Allan Guerin
Director

SUPPORT FOR THIS PUBLICATION

Mr. & Mrs. Bernard R. Brown
Ms. Marijo Dougherty & Mr. Norman Bauman
Mr. & Mrs. Stephen J. Garchik
Michael J. Gardner, M.D.
Mr. Jerry I. Speyer & Ms. Katherine Farley

EXHIBITION PARTICIPANT

A corresponding exhibition of
Larry Kagan's work will be presented at
Hirschl & Adler Modern, New York,
from September 11– October 11, 2014.

ACKNOWLEDGMENTS

I wish to acknowledge a number of people who are responsible for this exhibition and its catalogue.

Thanks are owed David Setford, former director of The Hyde Collection, for his original exhibition invitation, and Hyde board members Bernard R. Brown and Michael J. Gardner, M.D. for their early support; Charles Guerin, the present director, for his continuing efforts on behalf of the exhibition; and Erin Coe, chief curator, for her enthusiasm and professionalism. Her revealing and forgiving interview that is now part of this catalogue is most appreciated. Of course, thanks also go to the rest of the generous Hyde staff members with whom I came in contact during this project.

Sponsor support from organizations and collectors of my work, cited elsewhere on the catalogue pages, has enabled this publication, and I am indeed appreciative. I wish to especially thank Tom Parker of Hirschl & Adler Modern in New York for his belief in my work.

Special thanks go to Zheng Hu for his wonderful catalogue design; longtime friend and photographer Gary Gold for his sensitive and sympathetic photography; Dr. Roberto Casati, who with his essay brought an entirely new insight to looking at my sculpture; and my editor, Jeanne Finley, who made it all intelligible.

Finally I want to mention two special people: Marijo Dougherty, my life coach and studio curator, who made sure that everything that needed to happen for this project happened; and Nelson Bruns, who helps me so ably with all aspects of installing and lighting my shadows.

L.K.
2014

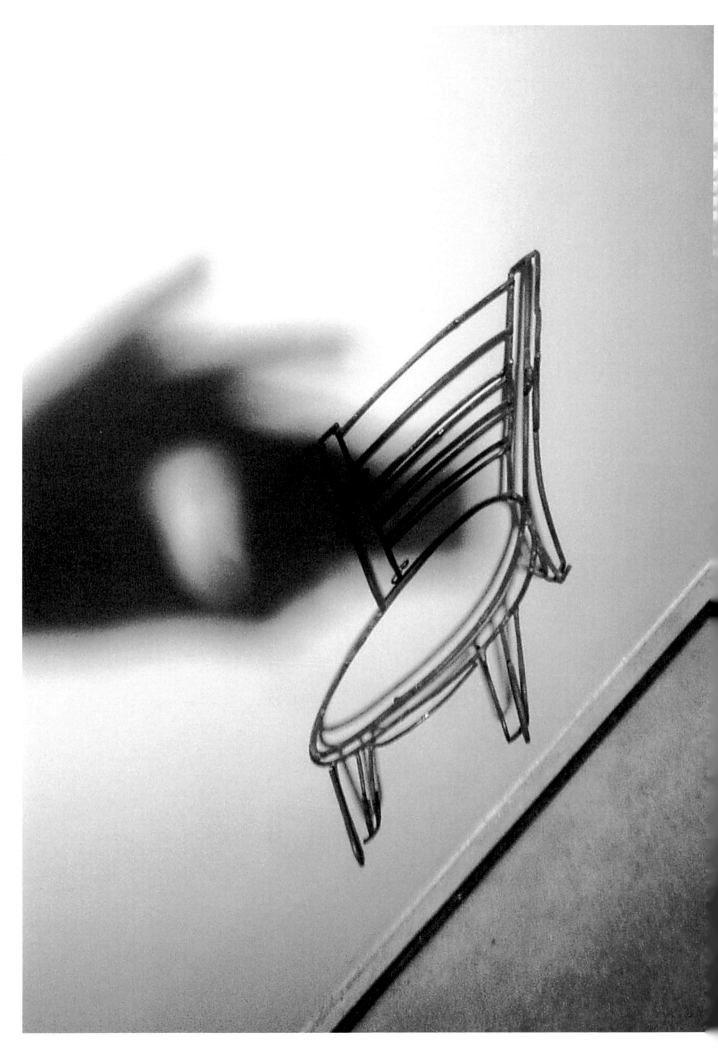

Incident Light

by Roberto Casati

Larry Kagan's studio is not like most sculptors' studios. An old adage has it that painters' windows should face north and sculptors' should face south, for paintings should be shielded from direct sunlight, while sculptures should bathe in light.

But Kagan's studio has no windows.

Sculptures and light—let alone shadows—are uneasy bedfellows. It should not be so. You can only see sculptures because there is light; you need shadow to appreciate volume and relief. Even the coldest, smoothest, roundest Canova would be a poor thing under poor light. But sculptures have an ability to span different sensory modalities; they can profess indifference to light. If painting is bound to be perceived through vision only, sculpture can indifferently be the object of sight *or* touch. Sight *or* touch: that means neither is fully necessary to an enjoyment of a sculpture; either is sufficient. We dare to say that sculpture talks directly to the spatial mind, and we use vision *or* touch as fungible vehicles of this discourse.

If only things were so simple, of course. The primacy of sculpture over painting has been contested time and again over the centuries. No argument is more dramatic than the one suggested by Galileo. In a striking thought experiment, he proposed to paint black the lit parts of a sculpture, and to paint white the dark parts.[i] This would dampen the shadow play on their surface and eventually convey an impression of flatness, obfuscating all concavities and convexities. Painting would get the upper hand over sculpture: it is because of *pictorial* cues—such as

Fig. 1 The forbidden, hidden sculpture hides its own shadow. (The shadow you see is the photographer's hand holding a camera close to the light source—a necessary artifact of this view of the chair).

the difference in dark and light spots in a visual scene—that we can see shapes in space.

Others, from Pliny to Alberti, took a completely different path, proposing painting was born out of shadow-casting,[ii] as if shadows—those natural, mechanical projections—were more trustworthy than the eye or the drawing hand; as if they were never distorted or their shapes never unreadable.

Larry Kagan does use light in his studio. Each sculpture he is working on has its own dedicated light spot. But the light is more than just an aid to see the sculpture. Actually, it makes the sculpture *less* visible.

I spoke about accidents of light. The dialectics of light and sculpture are predicated on the fact that on a comparable temporal scale, objects are stable and have stable properties, whereas light comes and goes. Objects *in* paintings, on the other hand, are blessed by a light of their own: timeless, still, mostly insensitive to the illumination the canvas itself may receive. But sculptures are fully exposed to the vagaries of light. How do they relate to light's offspring, shadows?

This question introduces us to an important spectrum of possibilities. At one extreme, some sculptures do not tolerate shadows, or accept them willy-nilly. Some sculptures cast accidental, inessential shadows. Midway through the spectrum, some sculptures have shadows as an essential ingredient, although more as an unavoidable by-product than as the result of an explicit intention. Some other sculptures are meant to cast shadows: such is their chore. The shadow is not only a necessary by-product—it is a design feature. And at the other extreme of the spectrum, some sculptures are *just* shadow-casters, in the sense that the shadow matters at least as much as, if not more than, the sculpture itself.

Larry Kagan's work stands at the latter end of this set of positions. His shadows are essential to his sculptures, are the object of an intention, and are equally as important, if not more, than the sculpture casting them.

Larry Kagan stipulates a contract with light, whereby the sculpture is assigned an unmovable light source set in a precise position. But we need to understand what the force of that contract is.

To that effect, I'd like to populate the Kagan end of the continuum with the workings of a few imaginary artists who, like him, play with shape, light, and shadow (of course, some of them may exist already, and Larry is—or has been—some of them). Philosophy, after all, is as much about deploying imagination constructively as art is.

One of these imaginary sculptors, the Shadow Disdainer, creates sculptures whose iron components are very similar to a Kagan sculpture, but which cast messy, meaningless, non-figurative shadows. You can shift from Kagan to the Shadow Disdainer by placing the contractual light source *somewhere else*, in non-canonical spots, just to see the shadow become timid and unconvincing. Conversely, the sculptures of the Shadow Confounder—again, iron-wise

superficially very much like Kagan's wires—cast shadows that do not look like shadows at all (Larry does some of those, too), while the Canova Shadower makes figurative sculptures that cast unremarkable shadows, although she insists that these boring shadows are essential, as essential as those of Kagan's sculptures. According to the Canova Shadower, you may be attracted to the sculpture, but you at least ought to look at the shadow in the first place.

These three characters may have to make a declarative statement to convince us that the shadow is essential. You simply do not *see* an intention to use shadows as part of the sculpture, so how would you know?

Then there is the Multiplier. The Multiplier creates countless sculptures, no one like any other in the series, whose shadows all have identical shape—so as to make it impossible for you to reverse-engineer a *particular* sculpture out of its shadow image (think of it: you can't for Kagan sculptures, either.)

These avatars indicate how fragile the status is of Kagan's work, how perilous—and challenging—his enterprise. The Canova Shadower, for instance, is the mirror image of Kagan along the representational dimension: Kagan's wires are in the norm non-figurative, while their shadows are; the Shadower's sculptures are figurative, while their shadows aren't. We may want to resist the idea that her sculptures have artistic status *because* of their shadows. Sure enough, categories are always tricky, the boundaries between them endlessly renegotiable: we maintain that a painted sculpture is a sculpture, rather than a three-dimensional painting. And that a painting with raised lines is a painting, rather than a flat sculpture. Intermediate cases put pressure on the negotiation; the easy way out is to create new labels, as we did with "bas-reliefs": half sculptures, half drawings.

Kagan's sculptures put further creative pressure on the categories. Do we ever pay attention to the wires, the solid part of his sculptures, at all? (It took me years before I noticed that they are phototropic, growing as they do like cones towards their dedicated, unreachable light.) In everyday perceptual practices we attend to the object and not to its shadow. Now if we do look at the shadows, and they are flat and figurative, is Kagan not sculpting but *drawing* with shadows instead? If our attention goes to the shadow—if the sculpture is only instrumental to the production of a shadow—aren't Kagan's works primarily *drawings*? And which kind of drawing style is this? Process drawing, maybe, incessantly re-created in time by the activity of the light bulb, photon after photon after photon. Would they simply not exist once the light is off?

Enough with thought experiments. I performed an unauthorized, real experiment in Larry's windowless studio: I put my eye (its electronic version, a camera) where the light was—or close enough to that position. From that forbidden position the shadow disappears, hidden beyond the material part of the sculpture. (Think of the sun, which never sees the shadows it casts.) And from there, the sculpture itself takes on a new, almost obscene life. The contours of each single line of wire merge

into one another; an outer summary contour consolidates; we end up seeing a glossy, distorted, unreal metallic chair. This unauthorized experiment uncovers the normative aspect of Kagan's "shadow sculptures," or Shasculptures, as we may call them. The forbidden viewpoint is forbidden, full stop. Which means that Shasculptures refer to sight essentially; shadows cannot be revealed by touch. But even more essential is the role of the negated viewpoint. A clause of Kagan's contract with light solemnly stipulates that the viewer is not allowed to look at the sculpture from the viewpoint of the light. Old-fashioned, rounded marble sculptures dictate that some viewpoints are impossible: you cannot interpenetrate the material, you cannot—and ought not—look at them from their inside. The limits of your vision are the limits of your body. Thus Kagan's sculptures set limits to vision that are the limits of light.

I wrote that shadows can be *components* of sculptures. In the end, I think this is the correct stance to take. Some sculptures just cast shadows, mere accidents of light. For others, the shadows are essential. But the power of Kagan's work is that it forces us to revise our inventory of the world: turning absences into parts of objects, furnishing our environment with hybrid creatures, half-concrete, half-ephemeral chimeras. Artists do happen to create representations of different, imagined, unheard-of worlds, but what they create are, in the norm, just representations. Few are the artists who can create new worlds *for real*.

[i] Letter from Galileo to Ludovico Cigoli, 26 June 1612. In Erwin Panofsky, "Galileo as a Critic of the Arts: Aesthetic Attitude and Scientific Thought," *Isis*, Vol. 47, No. 1 (1956): 3–15.

[ii] Pliny the Elder *Natural History* 35.12; Leon Battista Alberti, *De Statua*, ed. L.B. Alberti and M. Collareta (Livorno, Italy: Sillabe, 2006).

Hoop I, 2007

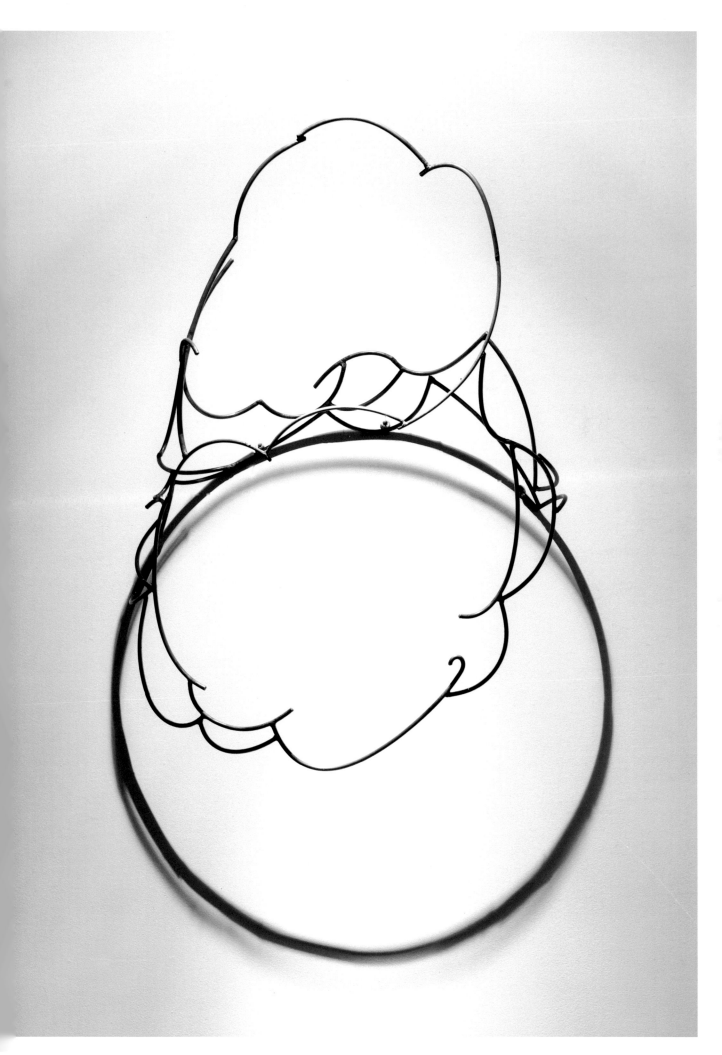

14

Interview with Larry Kagan

Interviewed by Erin B. Coe,
Chief Curator, The Hyde Collection
Recorded February 23, 2014

EC: My first question concerns the title of the exhibition, *Lying Shadows*. How do shadows lie?

LK: Generally shadows tell you about the objects that cast them. If you're an artist, you think of an object and the shadow that it's casting as one unit. The relationship between the shadow and the object tells you a lot about the shape of the object, where the light originates, what the atmospheric conditions are, the contrasts, and all of that.

EC: Or even the time of day?

LK: Exactly. So the idea is that we normally accept shadows as being quite truthful, in that they represent a particular aspect, a particular slice or projection of an object, and we respond to them knowing that they are truthful. That's useful to us from an evolutionary perspective. When you see a shadow overhead, you tend to duck reflexively because you assume there's some sort of danger that's about to befall. Now, the reality is that shadows, by compressing enough odd information, allow for an awful lot of uncertainty about the kinds of elements that produce the shadow, and one of the things that I noticed when I started working with shadows is that the unanticipated—the surprising relationship between the objects I'm

creating and the kinds of shadows they cast—seems to violate that kind of tacit assumption of truthfulness. So they sort of lie, in the sense that they give you a bunch of information about a presumed object's presence when it does not exist. In this case, there is no such thing as an eagle casting a shadow here, or a chair casting a shadow there. There's information about an eagle or a chair, but the objects themselves are just not there.

EC: Because they're illusions? The shadow the steel casts is an illusion of an eagle, or a stiletto, or a chair that doesn't, in reality, exist.

LK: It's not that they're illusions, it's that they imply the presence of purported objects, objects that are not present but are only represented by the steel structure, which captures only a small part of the visual information that would normally be involved. Because they rely on a very specific location of the light, it basically means that these images only exist for that particular instance when the light is exactly in the right place. Otherwise, they just go away.

EC: Shadows in nature are fugitive and transient. They are not static, but in your work they're fixed. They're very controlled.

LK: Well, that's like making a drawing. When you're making a drawing of something, you're essentially recreating one aspect of the object.

EC: Yes, but the drawing is permanent. The drawing or image doesn't disappear.

LK: It disappears if you turn the light off. In other words, you need to have light in order to see the drawing. You need to have a specific kind of light to see this sculpture—not only in location, but it has to be a light that is not diffuse so that the shadow actually appears sharp. I've been accused of creating tricks, but the trickery is only that it works with that one light source. Otherwise, there's nothing tricky here. What you see is real, but it captures only one very specific aspect of a real situation. The only thing that you can say is, well, there's a light over here; there's this kind of mess of steel over here; and there's an image it creates over here. But there's no other assumption you can make out of it, because it's a very discontinuous situation. You move the light and it disappears, but it's there, and it will reappear when the light is positioned correctly.

EC: This brings me to another point I want to discuss, which is the strong sense of absence and presence in your work. With the flick of a light switch, the image is gone. How do you account for that?

LK: Well, let's step back. When people ask me how I came up with this idea, generally I tell them the truth, which is basically that I had this idea of drawing with steel, and then the shadows kept interfering with the kinds of results I was getting, so I was forced to deal with the presence of shadows. So my investigation had a

lot to do with learning how to control shadow imagery and light and so on. But the first and the ultimate motivation behind my work is that I love working with steel. I mean, the shadow is transient, but the steel itself certainly isn't. I really do love welding and bending steel and working with it as a physical medium.

EC: Exactly. It's permanent, and the shadow isn't.

LK: No, but it can be recreated at any time. It's like having a slide, in a sense, except that a slide is a slide until you stick it into a slide projector. Then it's actually unlike a slide, which maps an image continuously; it's more like an electronic e-mail file, in the sense that the different parts in the file can be disconnected. They just have to come together when you're opening it. When you're sending an e-mail, all the information is broken up, different pieces are sent on different paths, and then at some point there is that address where they all come together, and then you've gotten the full message. Whereas with my work, you have a whole bunch of bits and pieces of curved steel in each piece of sculpture, each one trying to capture a different piece of the image, but they're dispersed in the sculpture until the light goes on, and the light pulls them back together. So it's ephemeral in the sense that it depends on the presence of light, but it's permanent in the sense that as long as the steel exists, and doesn't get misshapen or destroyed in some way, there is the possibility of putting a light source for it in the right place.

EC: You've been talking about sculpting and drawing. Do you see them as interchangeable? Can you describe your process? Are you sculpting the shadows, or are you drawing the shadows? Where do you fall in that process?

LK: In traditional sculpture, let's say we accept the idea of someone taking a big boulder or a big hunk of wood and then saying, "Aha, there's an image in there. I'm going to carve it out." Well, in my case, I'm starting with a beam of light, and then I chop away at it. I am actually not sculpting the shadow; what I'm doing is carving the beam of light, and what's left is the shadow. I keep taking away more and more of the light, and when I've sort of reached a point where I've taken enough of it away, and there's that continuous image that I want in the shadow, then I stop. So my sense is that creating the shadow drawing is very much like a musician playing a musical score, or like producing the image of what the sculptor has in his or her mind.

EC: From the block of stone...

LK: Right. It's in there.

EC: So it's subtractive, not additive.

LK: Yes, it's a subtractive kind of process. Obviously the paradox is that every piece of steel I add actually subtracts a piece of light.

EC: I next want to discuss Roberto Casati's essay, "Incident Light." He describes sculpture's relationship to light and the dialectics of light and sculpture, the vagaries or accidents of light and sculptural form. Whereas other sculptures are intended to cast shadows, as is the case with your work, the shadow matters as much, if not more, than the sculpture itself. He refers to this as your "contract with light."

LK: Well, I think that in a way he sets up a slightly false dichotomy by separating one from the other. Because my position is that if you take any object, from an aesthetic perspective the object and the shadow are one because there's always a necessary relationship between them. And in the sense that the shadow changes depending on the changing light, you actually have an infinite number of shadows that can be associated with any form. Every solid object can be said to have an infinity of shadows that are all bound up with it as one concept. Now, we normally don't pay attention to the shadows, we just look at objects and say, "Aha, there's an object there." But the reality is—and I think a photographer would be the first one to tell you this—that unless you are thinking of the object in relationship to the light, and the multiple ways that the light brings out the three-dimensional qualities of the object, you do not grasp the totality of the situation. In the wake of the light, there is always a kind of absence of light, so that they belong together. I don't think that people think of this unless they're artists. But they're aware of shadows, and if you think about shadow as a metaphor, you can find it everywhere, in poetry and in our everyday language. I mean, shadows are totally inherent in the way we understand the world. We just don't look at them. We're sort of aware of them in passing while we focus our attention on objects.

But going back to Roberto's essay: when he climbs to the top of the ladder and he doesn't see the shadow, he just sees the steel because the shadow is hiding on the opposite side. You wonder about what people grasp when they see these things for the first time. They notice a piece of steel that's being illuminated, and they're seeing an image, and they say to themselves, "Well, this can't be a shadow, because it doesn't look at all like the steel." So my question to them is: where is the shadow that the steel is casting? You don't necessarily hear them asking themselves, "Why isn't this piece of steel casting a shadow?" Well, it *is* casting a shadow. It's just casting a shadow that looks totally different than the steel.

EC: So it's the act of disbelief?

LK: I wonder why they don't ask themselves—when they don't believe that it's a shadow—"What happened to the shadow?"

EC: The word "shadow" has widespread metaphorical use in popular culture, from Robert Louis Stevenson's poem *My Shadow*, to the 1930s radio drama *The Shadow Knows*, to the groundhog casting its shadow. They're everywhere.

LK: I think that shadows are, in a way, critical. When I was little, I remember seeing an interesting illustration in a children's magazine I used to get, which was of a flock of sheep in Australia, and they all stood inside the shadow of a tree because it was too hot. And as the shadow moved, the sheep moved. These sheep knew inherently when they were too hot; they basically had to live in this kind of shaded area. So this image really sticks in my mind, but this notion of absence of light—the idea that when a cloud passes over you, you feel a sudden chill because it cuts out some of the warmth of the sun—that kind of stuff is part of it.

EC: Shadows certainly imply an element of mystery, as when someone is described as "living in the shadows," implying that he's leading a double life or holding a secret...how do shadow metaphors relate to your work?

LK: I did a show once where I started working with shadows and was experimenting with figuration. It consisted of a series of pieces that were images of people. One of the things I argued for was that, as a child of Holocaust survivors, most of whose extended family was wiped out, I lived with empty slots that normally would be occupied by cousins and aunts and uncles and all those who just weren't there. I was living with the shadows of these hypothetical, non-existent beings, so for me in a way the shadows symbolized their absence.

EC. That really gets to the heart of the sense of absence and presence in your work, and to the shadow as a metaphor for your own experience.

LK: Well, it's always dangerous to listen to what an artist has to say, because I think that a lot of the time we don't know why we do things—we tend to rationalize what we do. It's intuitive. But if I had to guess, I would guess that is maybe a part of it.

EC: How do you see your work in relation to the work of other artists who work with light? I'm thinking of artists like James Turrell or Dan Flavin.

LK: I do work with light, but the way that I got into it was really through working with steel, so its focus is different. Turrell's work has a lot more to do with the psychology of light, and what happens when you take away the normal depth and thickness cues, and what you have left then is a light plane that doesn't have anything physical to attach to. So it looks as if it's floating. Flavin works more with the qualities of light that have to do with wavelengths and primary and secondary kinds of relationships, where a reddish light will tend to produce a green after-effect. My work with light has to do much more with how it interacts with physical steel objects. There are a number of other people also who are working with cast shadows, but with different intentions. I go out of my way to force people to look at the shadow and the object at the same time. In a way, I'm sort of daring them to see a connection.

EC: Are you influenced by other artists who work with shadows? Who do you look at? How does your work act as a foil to theirs?

LK: Well, there aren't that many. There are few that I'm aware of, and they're mostly international. There's a Japanese woman named Kumi Yamashita who is working with figurative shadows, and there are a couple of British artists, Tim Noble and Sue Webster, whose typical work is a big pile of trash that somehow creates highly detailed figurative shadows. There is also a Belgian artist, Fred Eerdekens, who works with shadows as well. I learn a lot from looking at their work, but my primary inspiration is really just the idea that you can take a piece of steel and bend it and attach it to the wall and it casts a shadow. You can keep adding pieces of steel, and allow the shadow to grow, and then see what happens as a result. I draw my inspiration more from people like Dürer and others who really were terrific observers and whose work I constantly look to for inspiration.

EC: And draftsmen, too.

LK: I use steel as a drawing medium. It's drawing at a level one dimension removed from the actual shadow drawing. So it's interesting to me because I'm constructing something physical and creating a drawn image at the same time, and the interplay between the two creates an interesting space to work in.

EC: We're living in a post-Warhol era. Certainly Andy Warhol's impact still looms large over the art world. Your repertoire of popular and, in some cases, appropriated images, from the American eagle to George Washington to Dürer's hare to images by Keith Haring or Andy Warhol himself, foregrounds your work in the Pop Art tradition. Do you see yourself as a Pop artist? Are you grounded in that tradition?

LK: I do see myself in that tradition, both because the person I've worked closely with, my dealer (now deceased) Ivan Karp, was instrumental in encouraging Warhol to make art about common, ordinary subject matter, and because I go out of my way not to employ imagery that's overly expressive. I have a sense that shadows are a really painful way of making imagery. It's much easier just to draw something. If you want to get into expressing or developing lots of propaganda-like statements about the world, you're much better off drawing the stuff, or painting the stuff. I mean, why bother going through the whole effort of deconstructing the shadow/object relationship? So I just try and focus on the relationship between the object and the shadow, rather than look to allow the image to carry an overt message.

EC: Yes, but the exhibition features some powerful, inherently violent images, including the gun and the F-16 fighter jet. Are you deploying these in a manner similar to, for example, how Warhol used the Communist hammer and sickle to

neutralize what is otherwise a potentially inflammatory symbol, or as symbols that could carry other messages that have darker connotations?

LK: *Faber Got His Gun* was a reaction to reading a *New York Times* article with an illustration of a guy who was talking about what it was like to join the French Underground and fight against the Nazis. Here was this older guy, he must have been about seventy or seventy-plus by then, dragging out his old Luger and demonstrating how they went around resisting the German occupation. It struck me as something meaningful, but I don't know that I selected it for some ulterior kind of message. It just hit me that morning as I read the paper, and it got me to respond in some way. I put it aside and kept thinking about it. My general attitude is: there are all kinds of images floating around everywhere, and I keep collecting them and not using them. The ones that keep insisting on popping into my thinking I use, then after I use them they stop recurring and I can get involved in something else. As long as they keep bothering me, I keep working with them. I guess, if someone wants to really inquire about what my ulterior motives are, they're going to have to put me on a couch, because I have no idea.

EC: But your work is based on popular imagery. It's based on an image that you've appropriated from somewhere else.

LK: Well, my intention is primarily to use images that I'm exposed to. I choose the images that bypass the flatness of shadows and create the illusion of space, of depth in the wall. I try to incorporate either modeling or the issues of perspective to draw in the viewer, doing it with shadow, which is normally thought of as being a very flat medium.

EC: You've stated elsewhere that your recent work centers on body language, movement, and gesture. What is it about body language that intrigues you, and why has it become the focus of your recent work?

LK: I think that's my reaction to the Internet and to e-mail and to the incredible fights that people get in when they send a short message to someone and get back an angry response, whereas if they had said the same thing in person, and with a smile, their remark would be understood as a joke. In other words, it bothers me that we have compressed our communication channels and basically removed the whole dimension of body language—how we look at each other, how we lean toward each other when we want to pay attention, and all the rest of the body cues—from our daily "people interactions." There is this enormous level of information that passes between people when they are face to face, which totally disappears.

EC: In this electronic age...

LK: Yes. So in a way, it's my response to that kind of cheapening of communication.

EC: Your work inhabits the space between, as you said, the physical act of making art with steel and its conceptual by-product, the shadow. So you have this concept, which you think of as being a hands-off process, yet it's completely interdependent with the more traditional form of sculpting.

LK: Yes, and there's one other interesting element that we haven't really touched on, which is the idea that—assuming you're starting off with a shadow image you want to create, your image—there are an infinite number of ways of getting to it. The steel solutions are not unique. For example, if I want to recreate an image, I can do another piece of sculpture where the steel will look totally different, and yet it will still create an image that's very much alike—it won't be identical, but it will be pretty close. In that sense, it's like a musical score. It's always written and published the same way, but different performers and conductors will interpret it slightly differently, so that each performance becomes its own unique kind of esthetic experience.

EC: Have you made multiples of individual works?

LK: Yes, and I've had situations. For example, I did a golfer, and apparently there are a lot of people who play golf, so I kept getting requests. Chairs seem to be a popular kind of thing. There was a wooden folding chair that I did a number of times. There's a Bentwood chair that I did a number of times. When people encourage me to do another or to have another go at it or to try a different approach to it, it's an opportunity to really rethink the process, and that's kind of fun. Making art is fun.

EC: Explain how you engineer your pieces. I think many visitors to your show will ask, how does he do it?

LK: It's totally intuitive in the sense that it depends on a lot of trial and error. It's no different than using your hands to cast animal shadows on the wall. It's not terribly mysterious or anything. It's just mysterious when you look at it at the end and don't see the actual process.

EC: They're not sure...the visitor isn't clear about what's casting the shadow.

LK: Take Dürer's hare, for example. When you look at the Dürer, you marvel at the beautiful drawing that captures an awful lot of stuff about the animal, its spirit and surroundings. But you're seeing a completed piece. It's all compressed, all done. You're not seeing the process, you're seeing the final product. With this sculpture, you can actually see the steps. As each piece of steel is added, a piece of shadow gets created. The steel itself reveals the history of how the shadow is produced because the pieces that are farthest from the wall are generally the latest additions. It's all there in time for you to read. You can actually decipher how this image came about.

EC: Do you see the construction of the wire sculpture as an act of alchemy?

LK: Well, yes. It's magic. Poof!

EC: Where do you see your work evolving from this point forward?

LK: You know, I've been on this path to learn about shadows as a medium, and I'm finding that the more deeply I'm involved with them, the more expressive and creative possibilities emerge. As long as I keep finding new insights into shadows, and they stay interesting, I think I'm going to keep exploring them.

EC: So you're sticking with shadows?

LK: Well, I'm sticking with steel as long as I have a supply of steel. I'm good for now.

PLATES

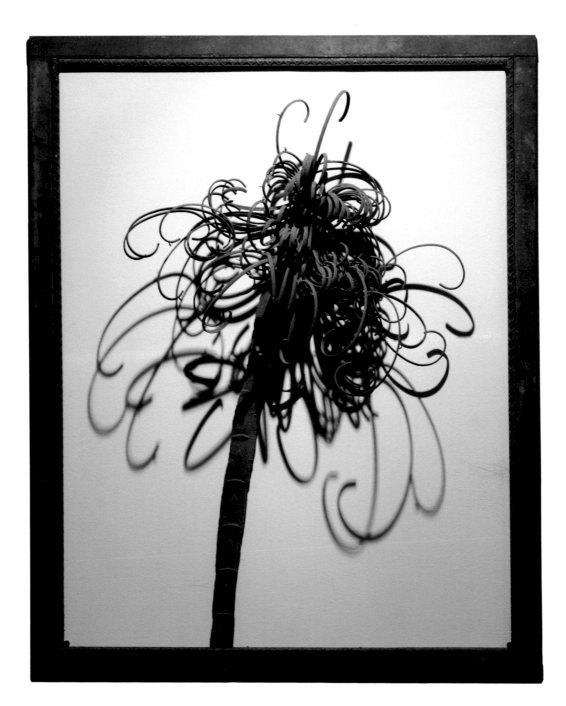

Chrysanthemum, 1992

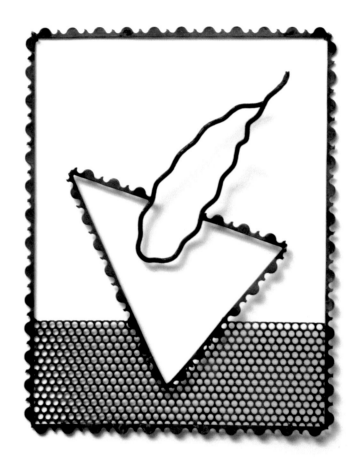

Burning Triangle, 1996

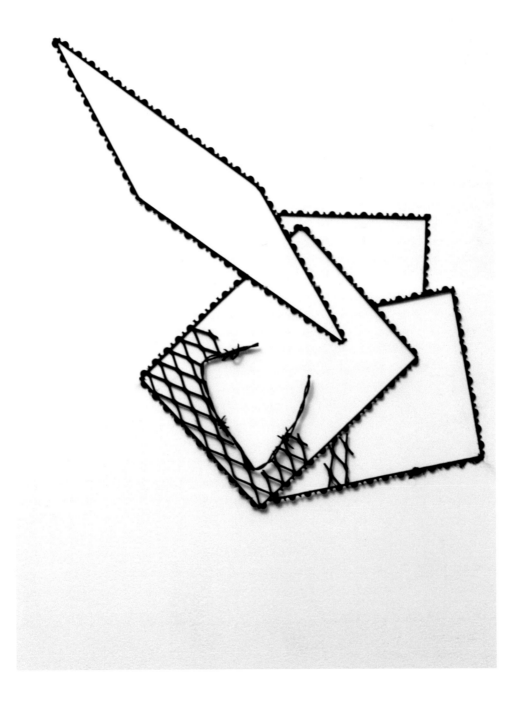

Concentration, 1996

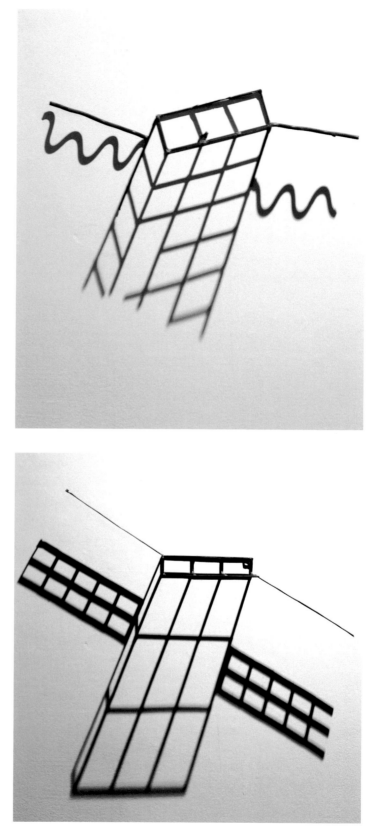

Hidden Wave, 1997

Hidden Lines, 1997

28

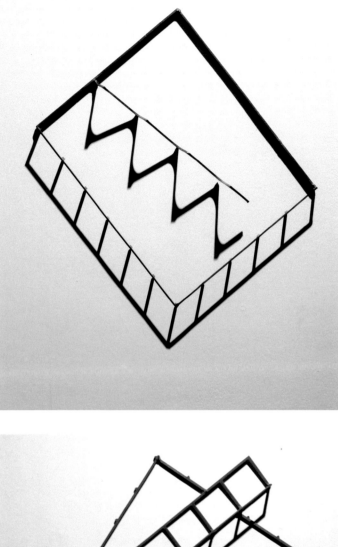

Cracked Slab, 1998

Box on Slab, 1998

29

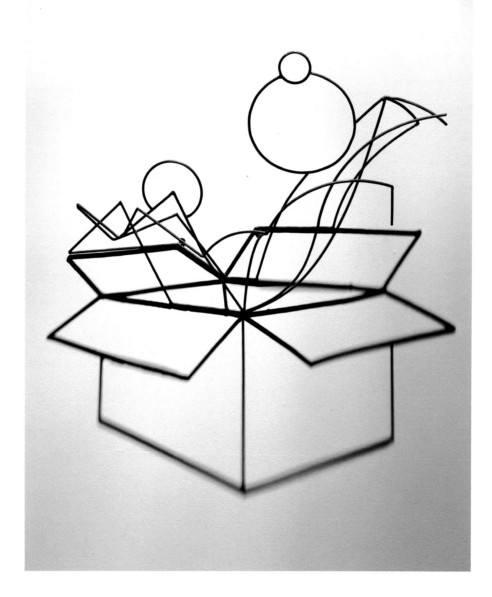

Box II, 2000

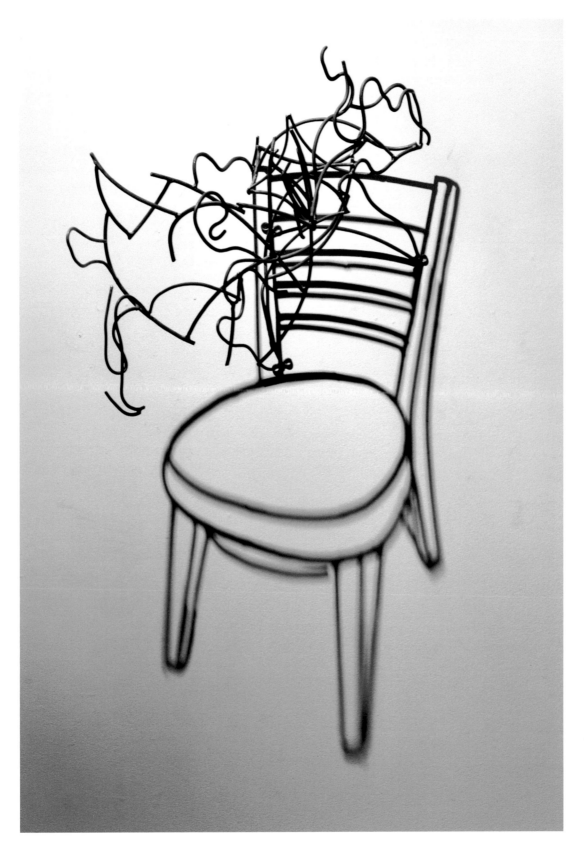

Frankfurt Chair, 2002

31

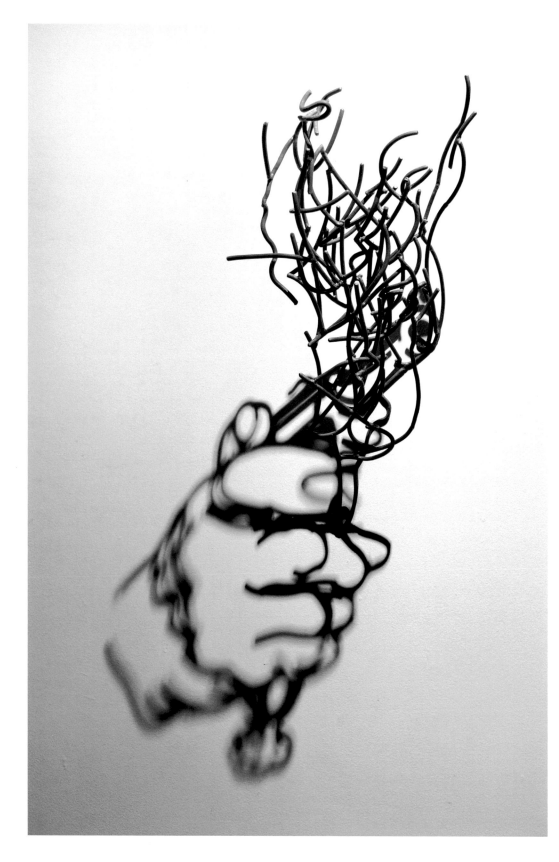

Faber Got His Gun, 2002

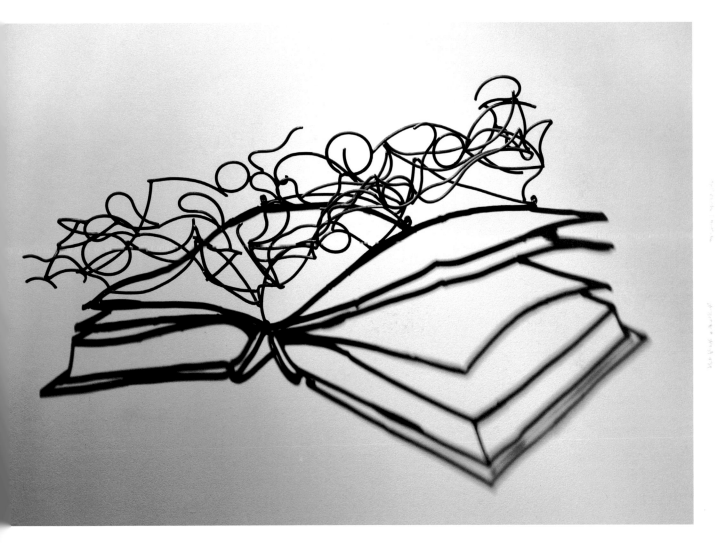

Great Book, 2004

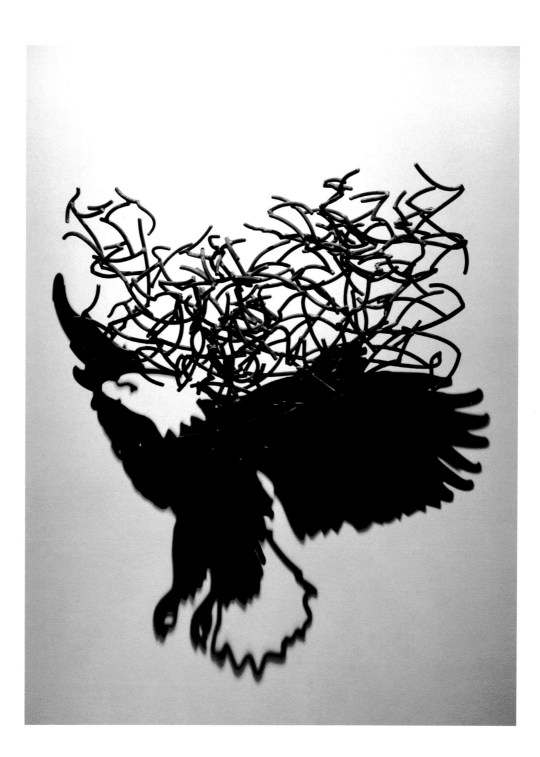

Bald Eagle, 2005

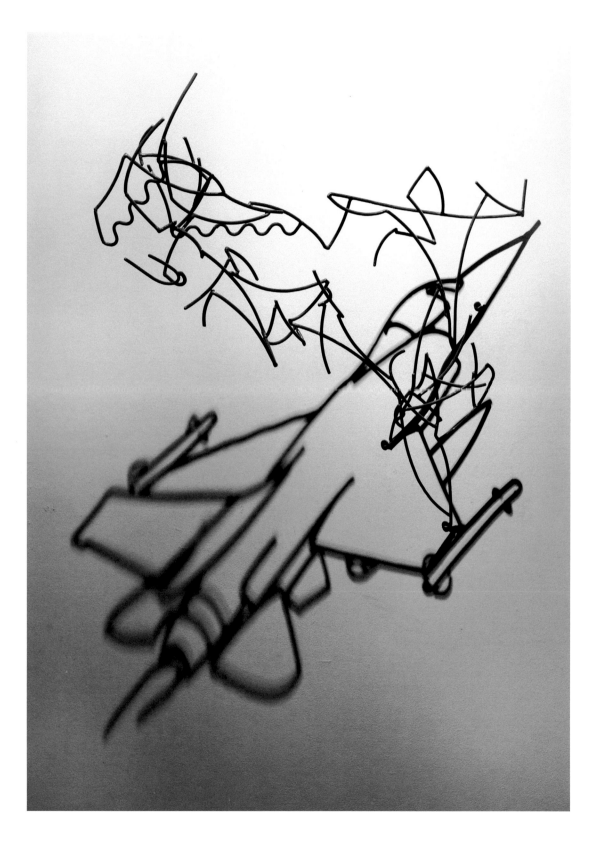

F-16, 2003

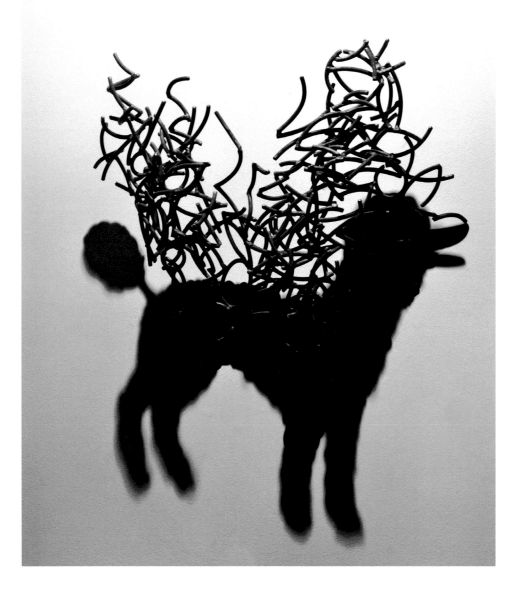

Poodle, 2005

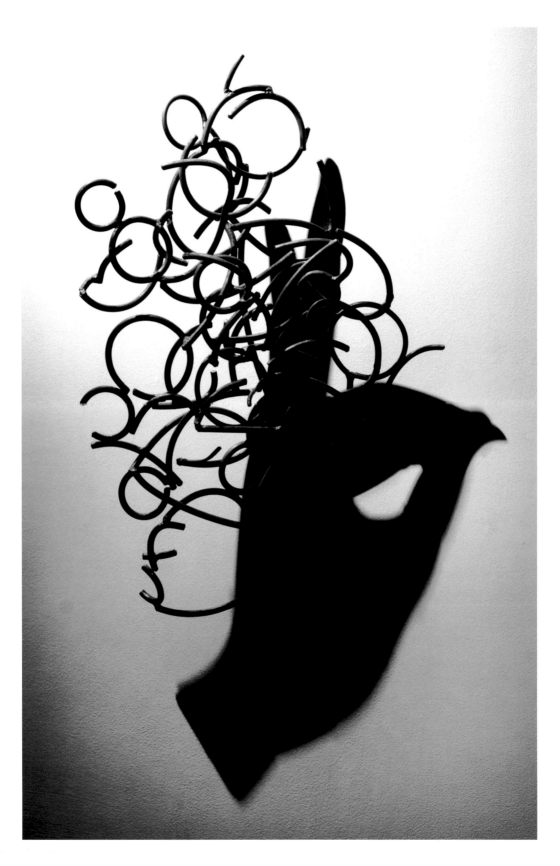

Shadow Puppet II, 2007

Ode to Keith, 2006

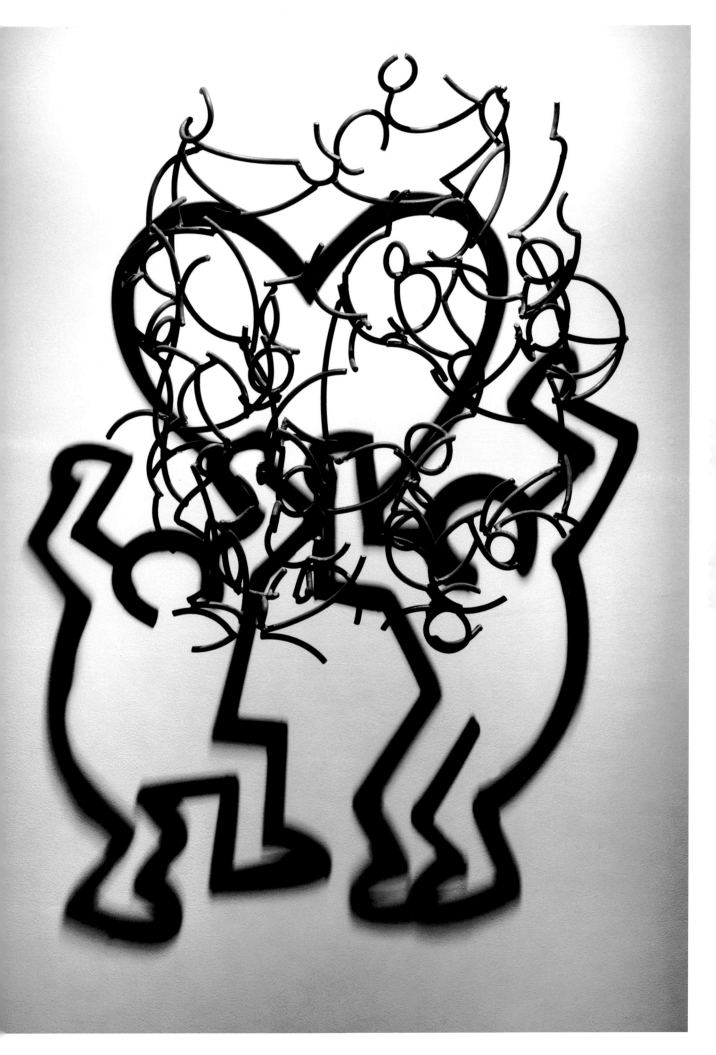

Mosquito #7, 2007

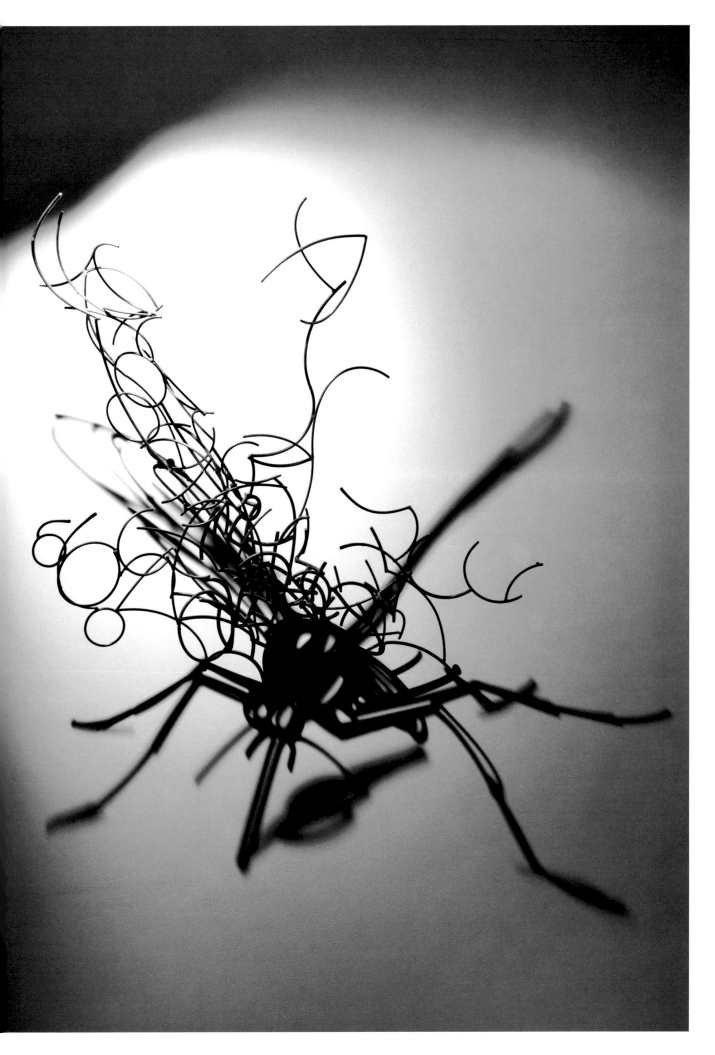

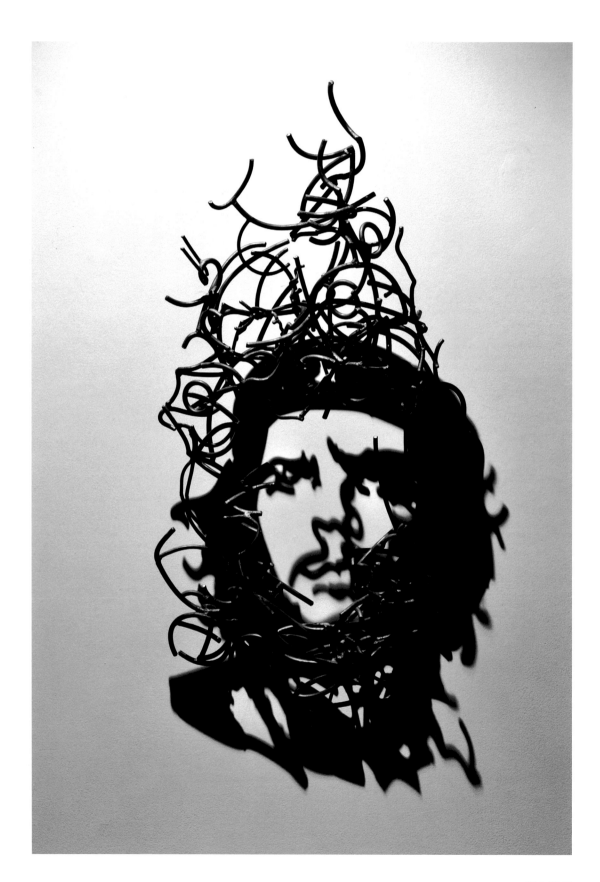

Ché, 2009

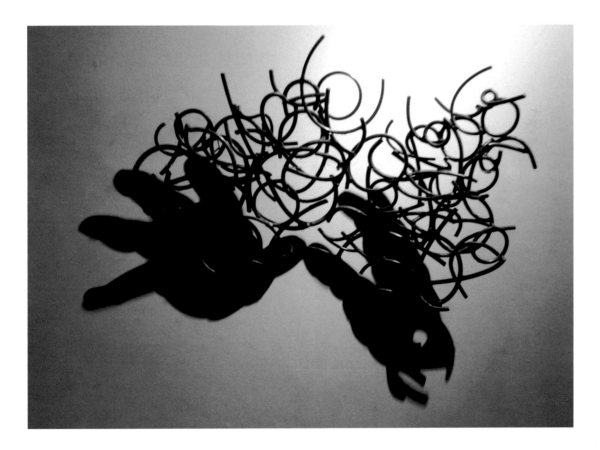

Abdel's Hands, 2010

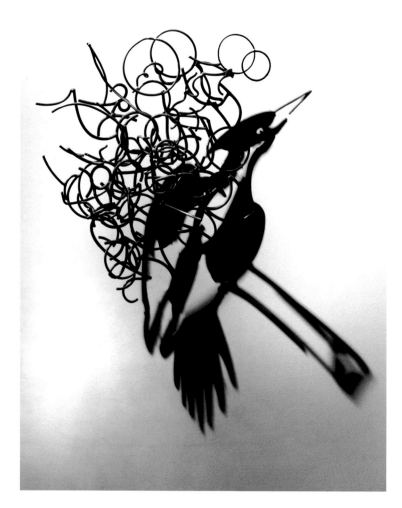

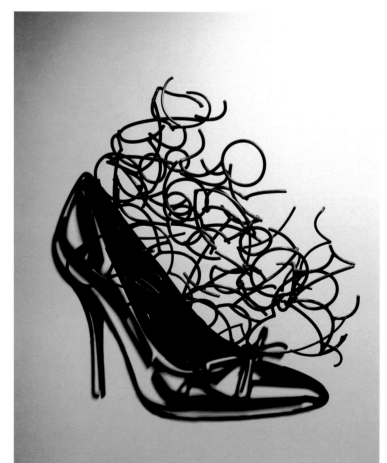

Audubon's Woodpecker,
2010

Stiletto II, 2010

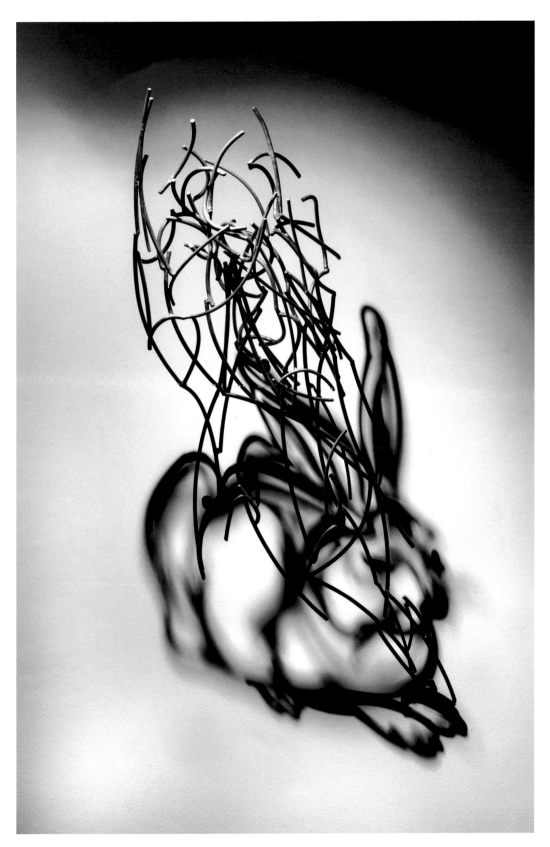

Dürer's Hare, 2010

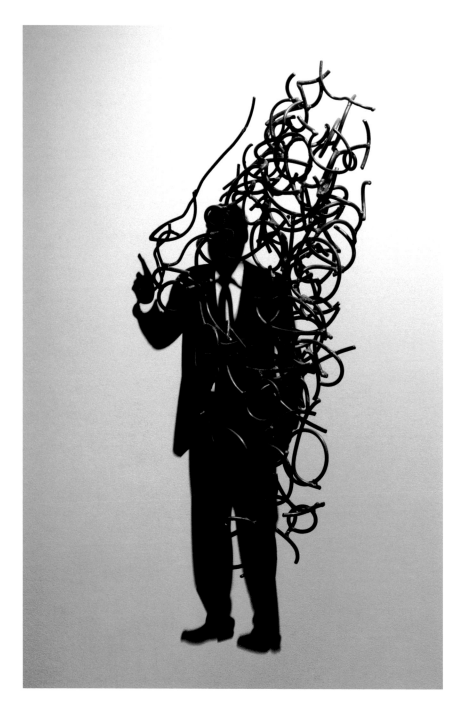

One More Thing, 2011

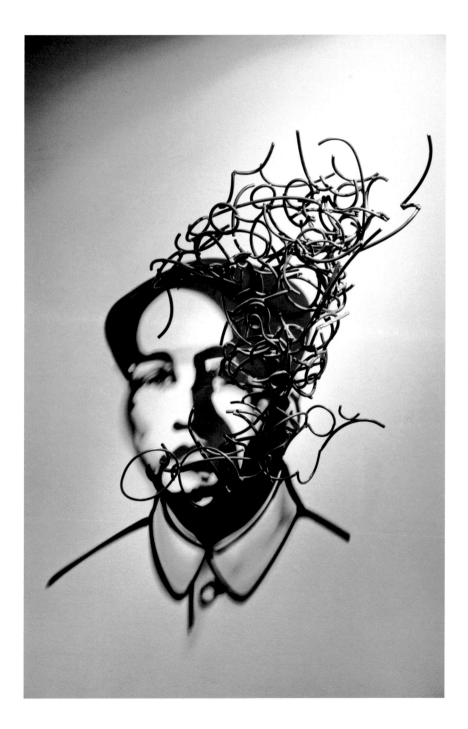

Young Mao, 2011

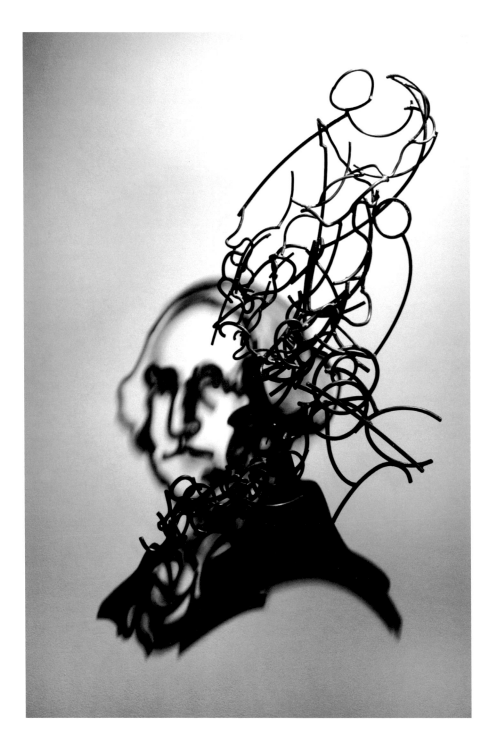

George, 2012

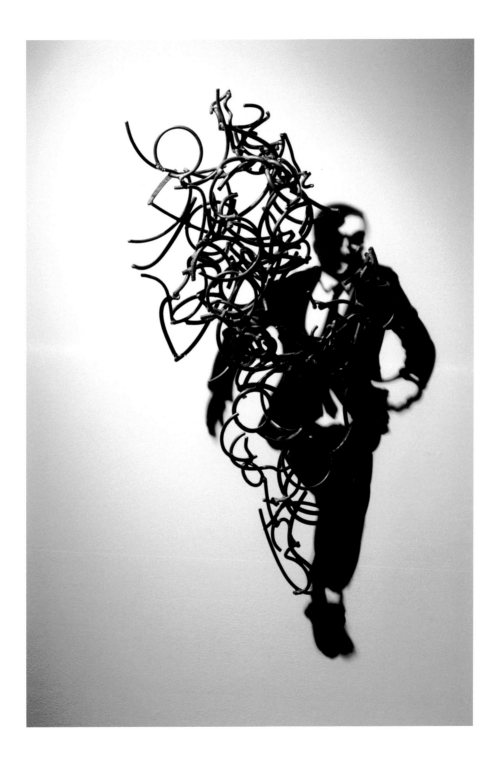

Running Man, 2012

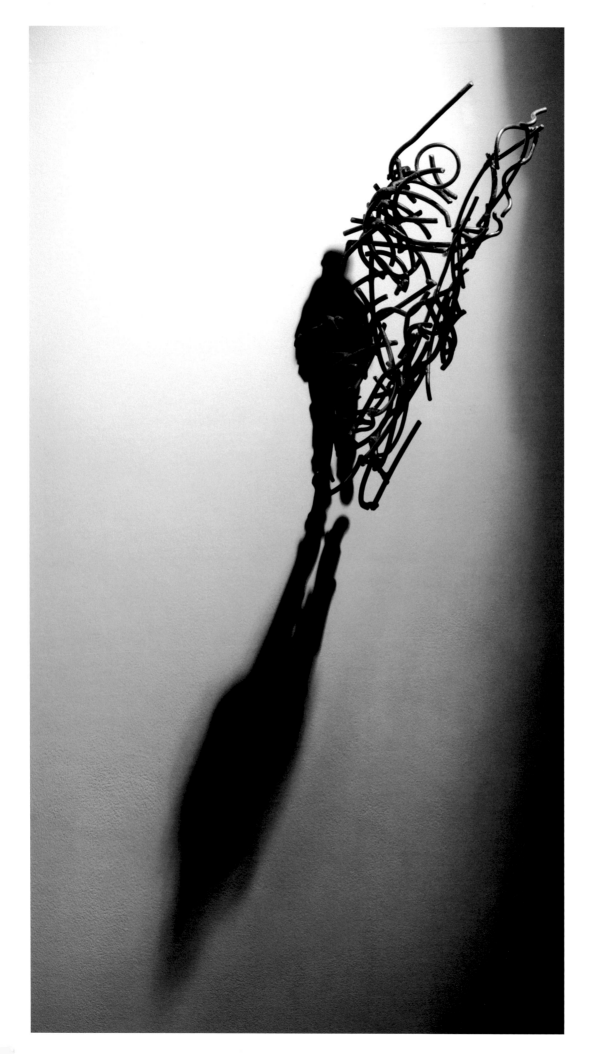

Long Shadow, 2013

EXHIBITION CHECKLIST

All works are by Larry Kagan (American, born 1946) and are from the collection of the artist, except as noted. Dimensions given are for the sculpture with shadow—height x width x depth.

Chrysanthemum, 1992
Steel and shadow
34 x 28½ x 6 inches

Burning Triangle, 1996
Steel and shadow
12½ x 10 x 2½ inches

Concentration, 1996
Steel and shadow
26 x 22 x ¾ inches

Hidden Lines, 1997
Steel and shadow
24 x 10 x 7 inches

Hidden Wave, 1997
Steel and shadow
5 x 19 x 5½ inches

Box on Slab, 1998
Steel and shadow
26 x 24 x ½ inches

Cracked Slab, 1998
Steel and shadow
16 x 18 x 2 inches

Box II, 2000
Steel and shadow
34 x 35 x 10¾ inches

Faber Got His Gun, 2002
Steel and shadow
38 x 20 x 14½ inches

Frankfurt Chair, 2002
Steel and shadow
46 x 25 x 14½ inches

F-16, 2003
Steel and shadow
45 x 35 x 15½ inches

Great Book, 2004
Steel and shadow
34 x 52 x 12 inches

Bald Eagle, 2005
Steel and shadow
39 x 37 x 12¼ inches

Poodle, 2005
Steel and shadow
29 x 24 x 9 inches

Ode to Keith, 2006
Steel and shadow
54 x 41 x 9 inches

Hoop I, 2007
Steel and shadow
56 x 36 x 10 inches

Mosquito #7, 2007
Steel and shadow
69 x 63 x 17 inches

Shadow Puppet II, 2007
Steel and shadow
42 x 25 x 8½ inches

Ché, 2009
Steel and shadow
50 x 27 x 12 inches

Abdel's Hands, 2010
Steel and shadow
28 x 33 x 8¼ inches

Audubon's Woodpecker, 2010
Steel and shadow
40 x 26 x 11½ inches

Dürer's Hare, 2010
Steel and shadow
46 x 19 x 14 inches

Stiletto II, 2010
Steel and shadow
31 x 28 x 10½ inches

One More Thing, 2011
Steel and shadow
44 x 18 x 12 inches

Young Mao, 2011
Steel and shadow
43 x 33 x 16 inches

George, 2012
Steel and shadow
44 x 28 x 13 inches

Running Man, 2012
Steel and shadow
34 x 18 x 11 inches
Private collection,
New York

Long Shadow, 2013
Steel and shadow
52 x 14 x 18 inches

This catalogue was published on occasion of the exhibition
Larry Kagan: Lying Shadows at The Hyde Collection,
Glens Falls, New York, June 14 – September 14, 2014.

Cover: Larry Kagan, _Running Man_, 2012
Steel and shadow, 34 x 18 x 11 inches
Private collection, New York

Guest Essayist: Roberto Casati
Designer: Zheng Hu
Printer: Quality Printing Company,
 Pittsfield, Massachusetts
Editor: Jeanne Finley
Photography: Gary Gold

Accredited by
The American Alliance of Museums

Charles A. Guerin, Director
Erin B. Coe, Chief Curator
Alice Grether, Director of Communications
 and Visitor Services
Susan Bishop, Assistant Curator

Kelli Ariel, Barbara Bertucio, Evi Fisher, June Leary,
Deborah Lee, Lynne Mason, Sandee O'Keefe,
Dede Potter, Tim Raffile, Dave Sweet, Kathy Reed,
Terry Vanier, and Ann Whelan

Adobe Futura Book® set on Explorer 100 lb. dull text
2000 editions
ISBN: 978-0-9606718-6-1

State of the Arts

NYSCA

New York State Council on the Arts with the support of
Governor Andrew Cuomo and the New York State Legislature